Southampton Ontario in Photos, Saving Our History One Photo at a Time

Photography
by Barbara Raué
2013

Series Name:
Cruising Ontario

Book 33: Southampton

Cover photo: 125 High Street

Series Name: Cruising Ontario

Book 1: London
Book 2: Dundas
Book 3: Hamilton
Book 4: Oakville
Book 5: Chesley
Book 6: Stoney Creek
Book 7: Waterdown
Book 8: Owen Sound
Book 9: Mount Forest
Book 10: Dundalk
Book 11: Burford
Book 12: Waterford
Book 13: Drumbo
Book 14: Sheffield
Book 15: Tavistock
Book 16: Ancaster and Mount Hope
Book 17: Innerkip
Book 18: Brantford
Book 19: Burlington
Book 20: Guelph
Book 21: Ayr
Book 22: Erin
Book 23: Goderich
Book 24: Lucknow
Book 25: Paris
Book 26: Toronto
Book 27: Beaver Valley
Book 28: Collingwood
Book 29: Peterborough
Book 30: Orangeville Beginnings Part 1
Book 31: Orangeville Part 2 and Area
Book 32: Port Elgin
Book 33: Southampton
Book 34: Jarvis

Other Books by Barbara Raue

Coins of Gold

Arrows, Indians and Love

The Life and Times of Barbara
Volume 1: Inventions That Have Enhanced My Life
Volume 2: Entertainment That I Have Enjoyed
Volume 3: East Coast Trips
Volume 4: Olympics Have Always Intrigued Me
Volume 5: Wonders of the World
Volume 6: Caribbean Cruises We Have Enjoyed
Volume 7: Animals
Volume 8: Storms and Other Major Disasters in My Lifetime
Volume 9: Wars, Terrorist Attacks and Major Disasters

The Cromwell Family Book

Visit Barbara's website to view all of her books
http://barbararaue.ericraue.com

Southampton

Southampton is located on Lake Huron at the mouth of the Saugeen River. It is located south of Sauble Beach and north of Port Elgin.

In the spring of 1848, Captain John Spence, a native of the Orkney Islands in northern Scotland, arrived at the mouth of the Saugeen River after an overland journey on foot from Owen Sound. He was impressed with the potential of the area, returned to Owen Sound for provisions and the following year built a cabin near the mouth of the river, becoming Southampton's first permanent settler. His wife and family joined him in 1850. He bought the fishing schooner "Sea Gull" for coastal trade along the shores of Lake Huron.

It is quiet and peaceful on Southampton's beach, a four-kilometre-long stretch of shore. The wooden Long Dock extends towards Chantry Island with its lighthouse in view offshore.

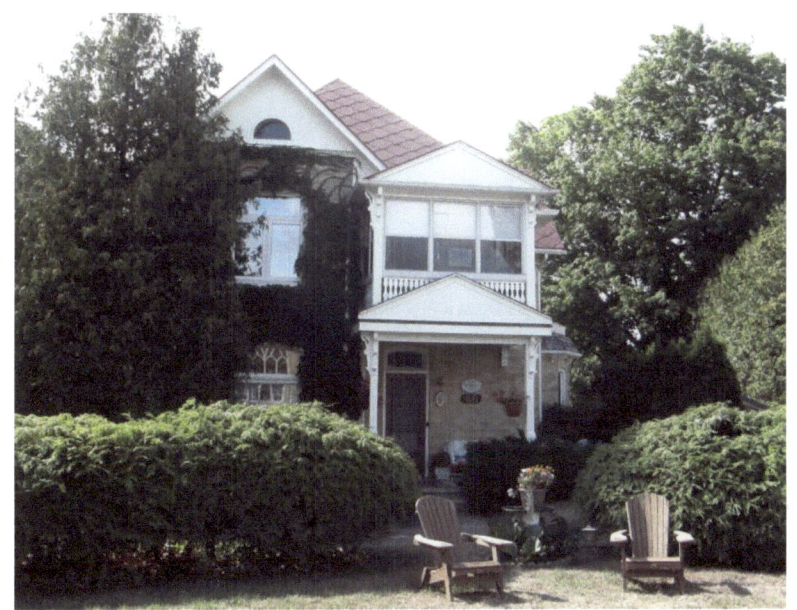

48 Albert Street North - B. A. Belyea, Merchant – c. 1895

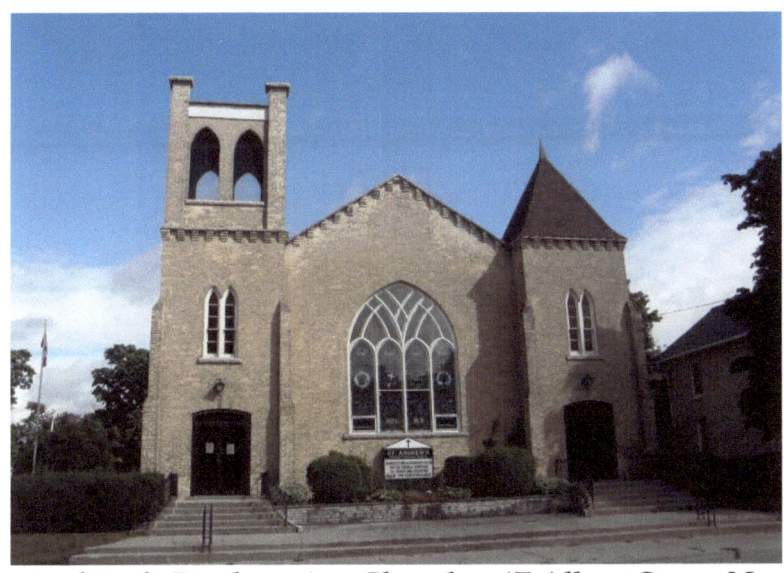

St. Andrew's Presbyterian Church – 47 Albert Street North

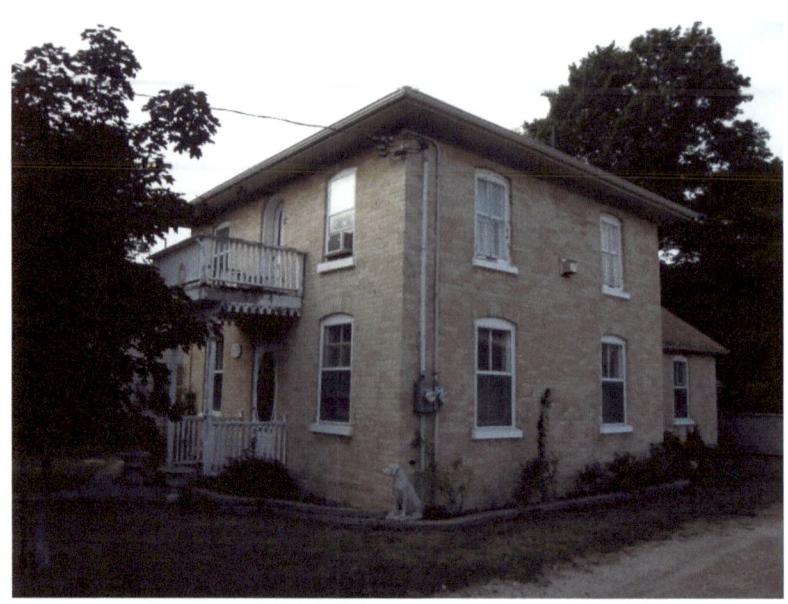

George McNabb, Labourer – c. 1890
Yellow brick, Italianate style

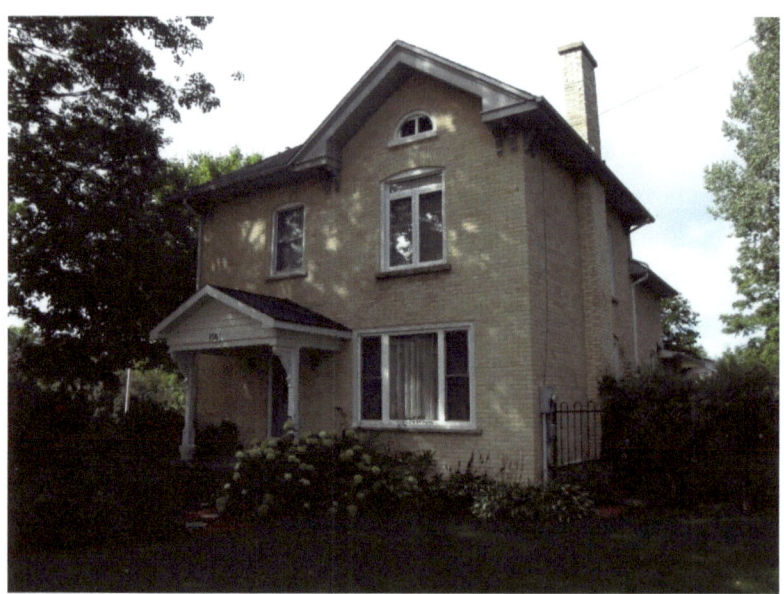

156 Albert Street North – Italianate style with paired cornice brackets with Gothic style gable with cornice return

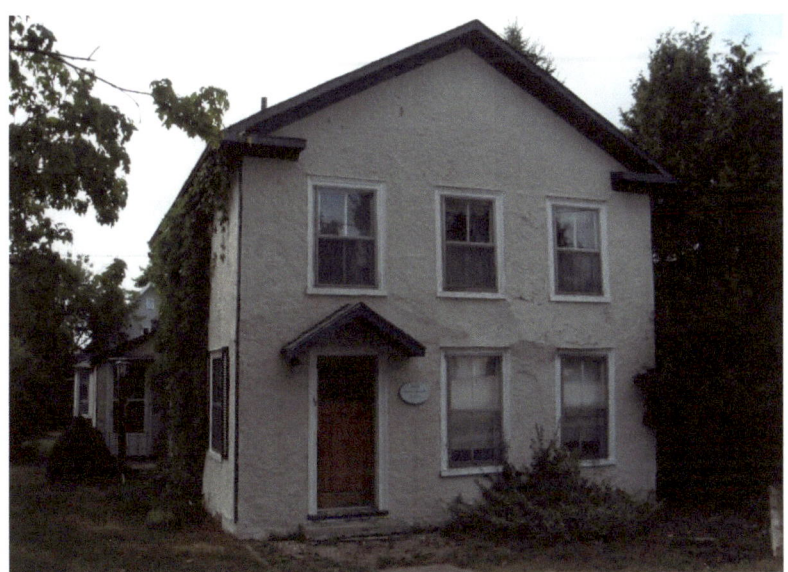

Robert Neelands, Carpenter – c. 1868 – stucco exterior
Gothic style – cornice return on gable

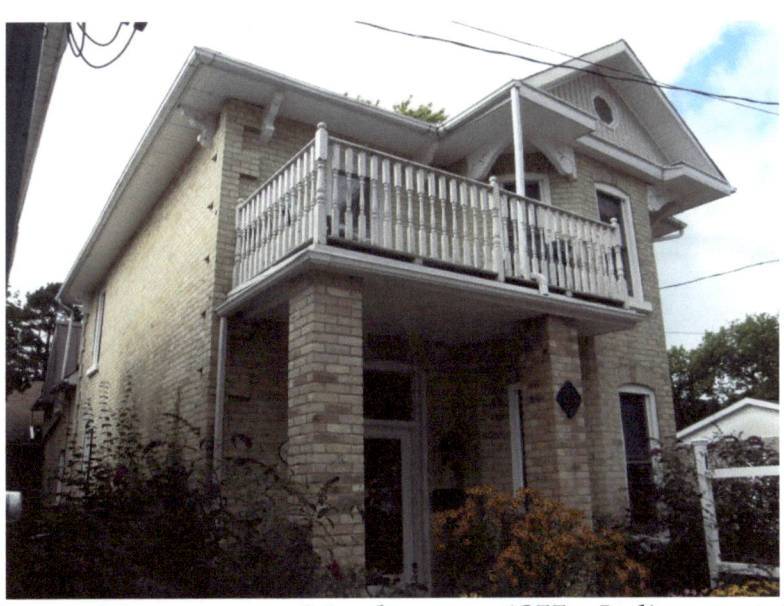

Thomas Montgomery, Merchant – c. 1855 – Italianate style
Two-and-a-half storey tower-like bay with projecting eaves
and large fretwork pieces resembling brackets

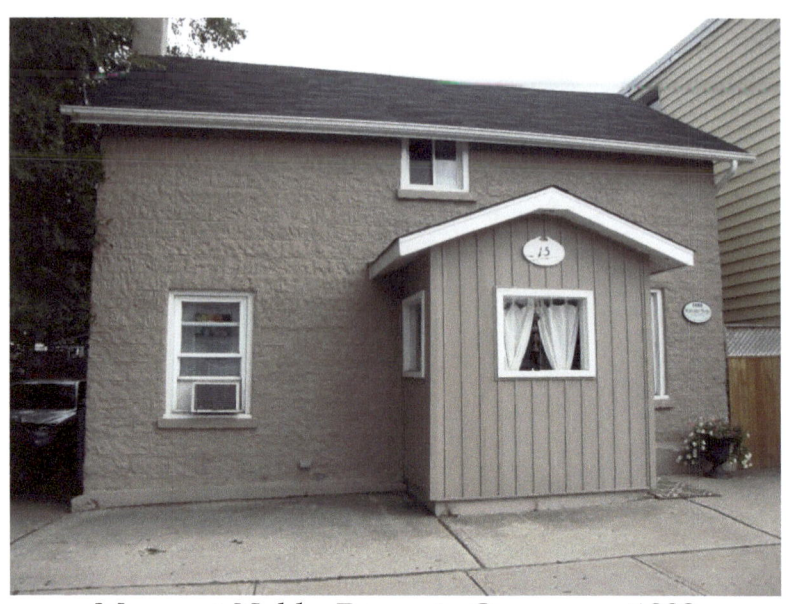

Margaret Noble, Property Owner – c. 1888
15 Albert Street North

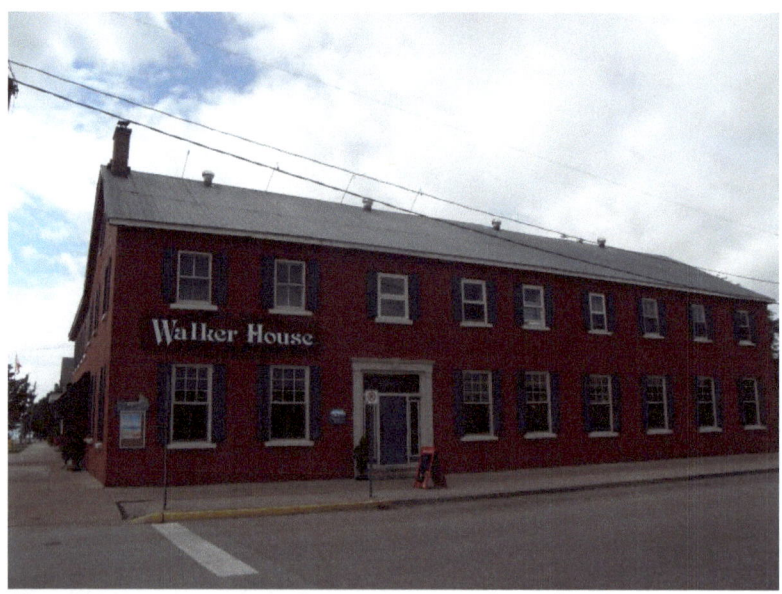

Walker House – a popular meeting place for food and spirits since 1915 – Georgian style – 146 High Street – a historic hotel in the village since the 1860s

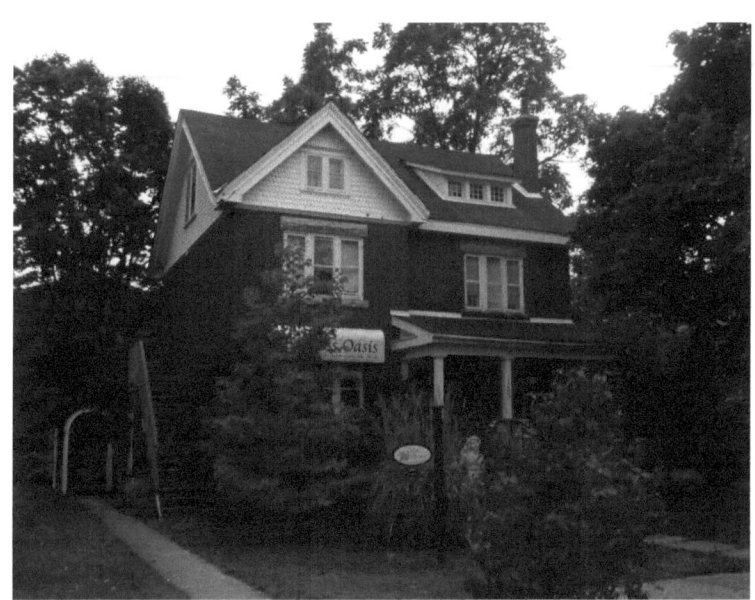

135 High Street - Gothic Revival
Charles Joseph Laird, Physician – c. 1904

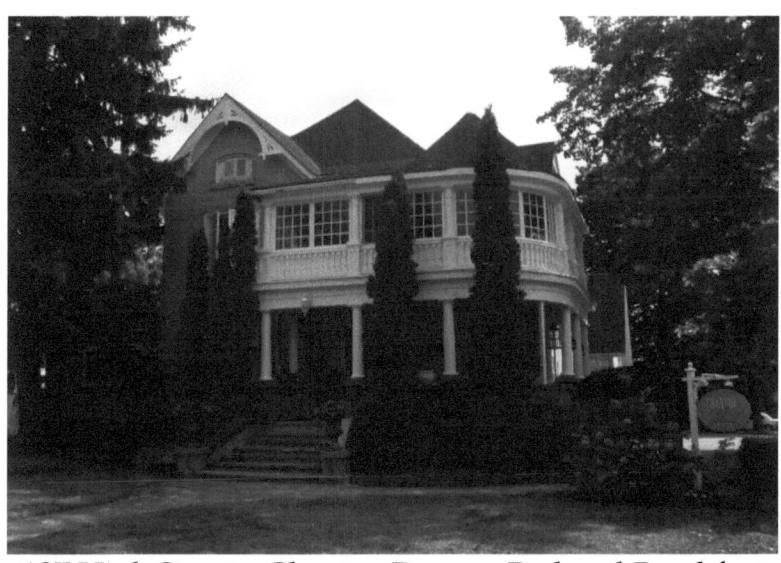

107 High Street - Chantry Breezes Bed and Breakfast
George E. Smith, Customs Officer c. 1907 – Queen Anne style

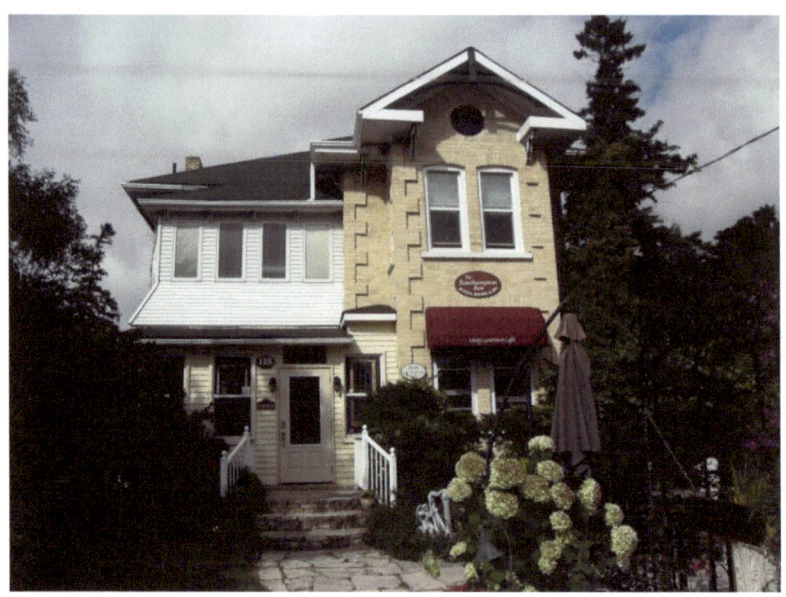

118 High Street, The Southampton Inn – quoining on corners, cornice return on gable – Captain "Dan" McAulay, Mariner, 1896 - Italianate style with two-and-a-half storey tower-like bay with projecting eaves, single cornice brackets

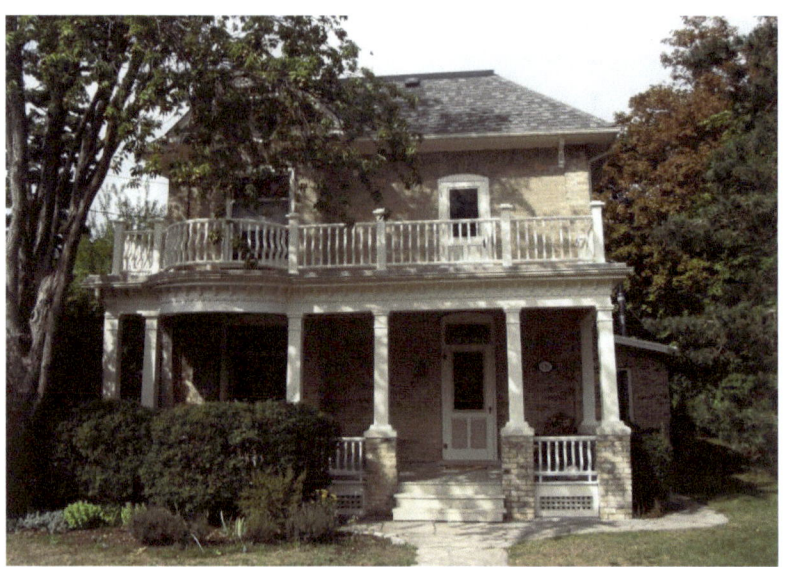

126 High Street – Italianate style, yellow brick

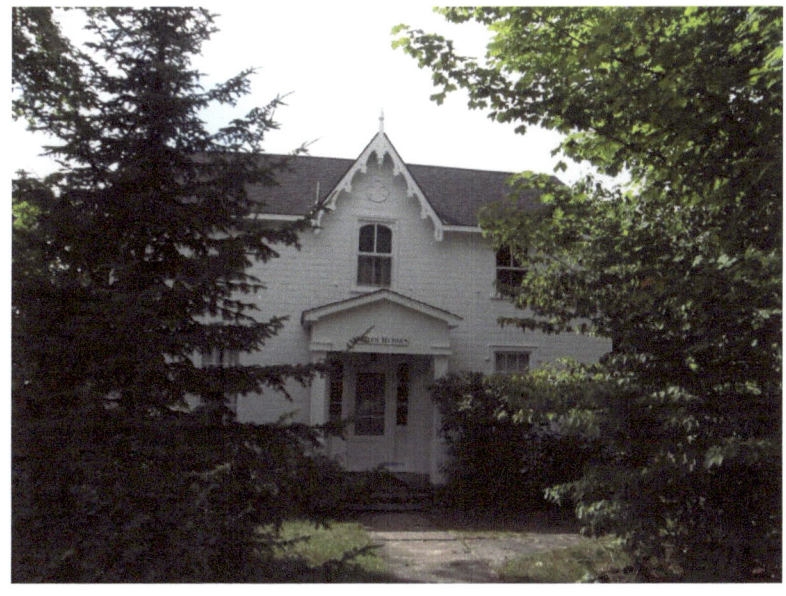

Glen Huron – Gothic Revival, Vergeboard and finial on gable

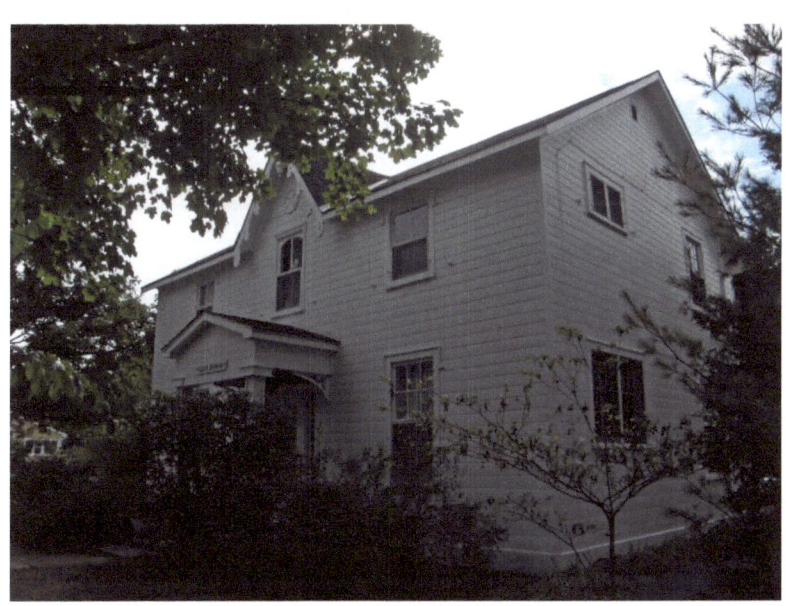

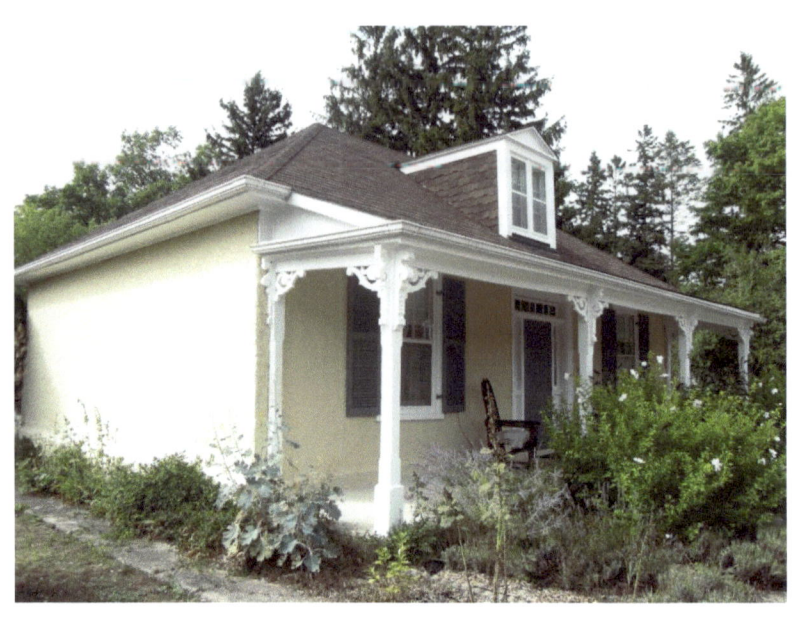

Captain Spence built this house c. 1850 – one-and-a-half storey Regency Cottage – 18 Huron Street North

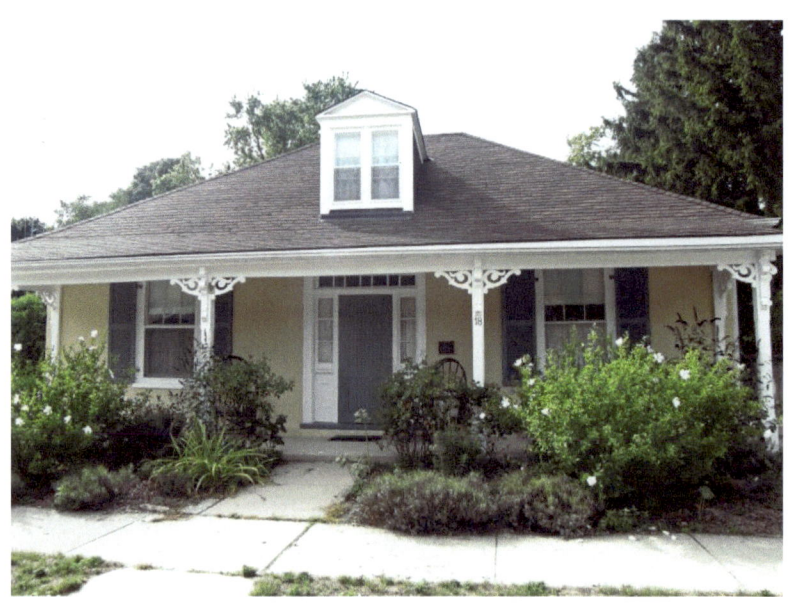

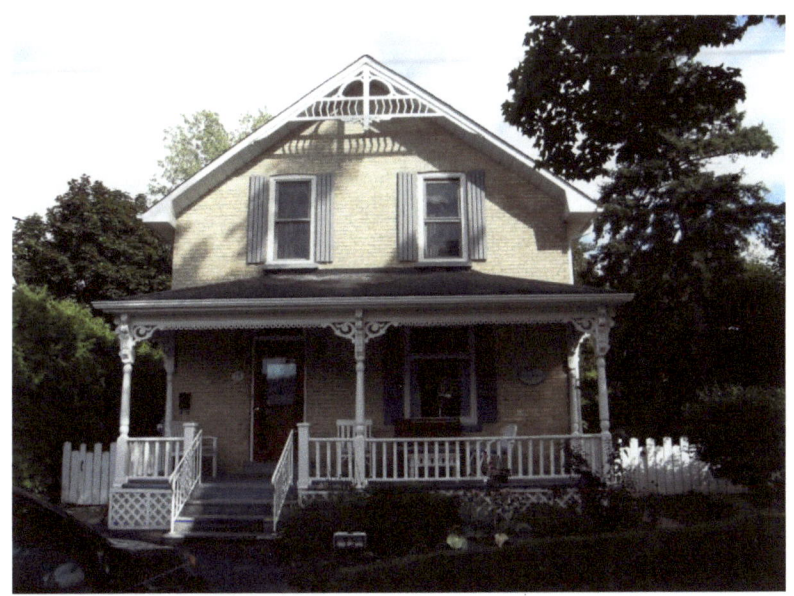

15 Huron Street North - Peter Longe, Fisherman
c. 1912 – Gothic Revival

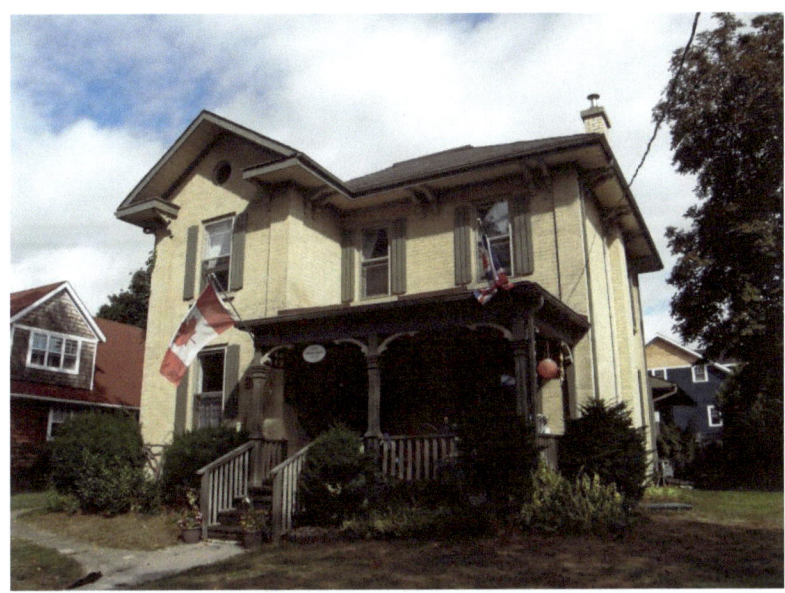

25 Huron Street North – Magnus Spence, Gentleman – 1896
Italianate style with two-and-a-half storey tower-like bay with
projecting eaves, paired cornice brackets, cornice return on gable

42 Huron Street - Alexander Hutchinson, Telegraph Inspector
c. 1876 – one storey Regency Cottage

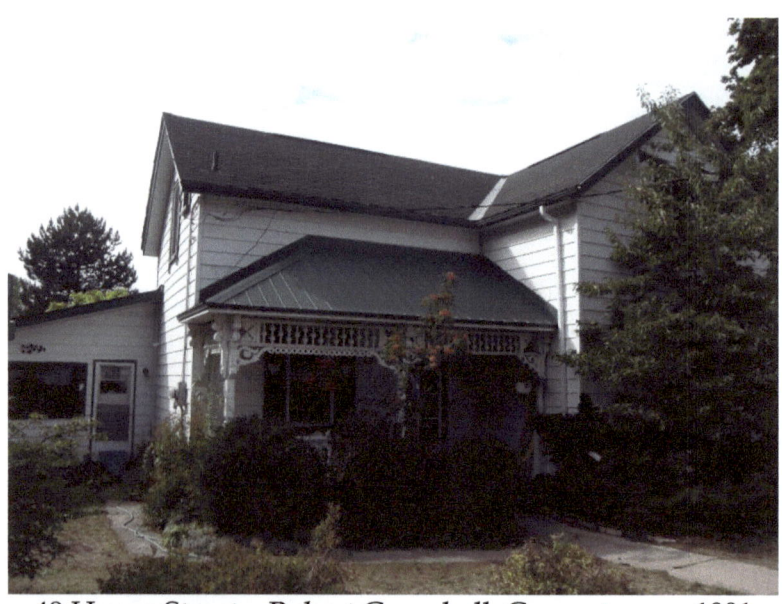

49 Huron Street – Robert Campbell, Carpenter – c. 1901
Gothic Revival – Beachside Cottages

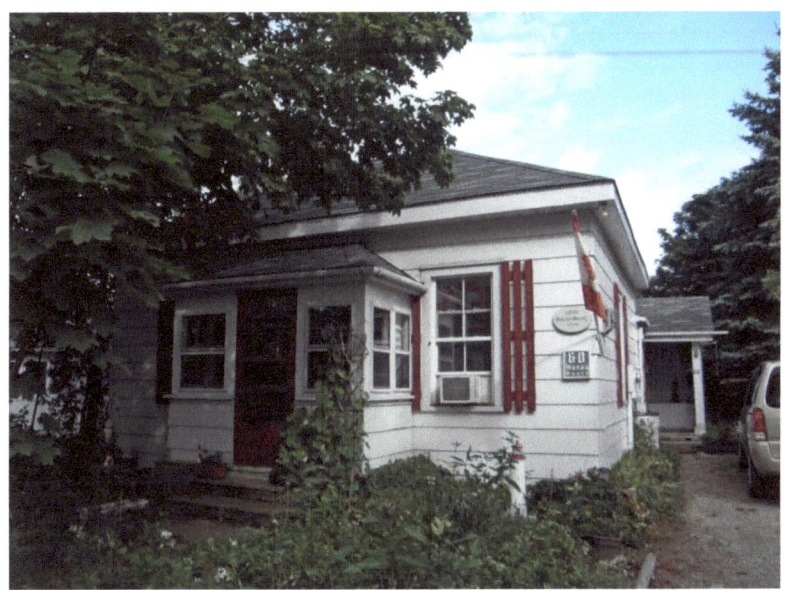

60 Huron South - Malcolm Murray, Fisherman – c. 1890
one storey Regency Cottage

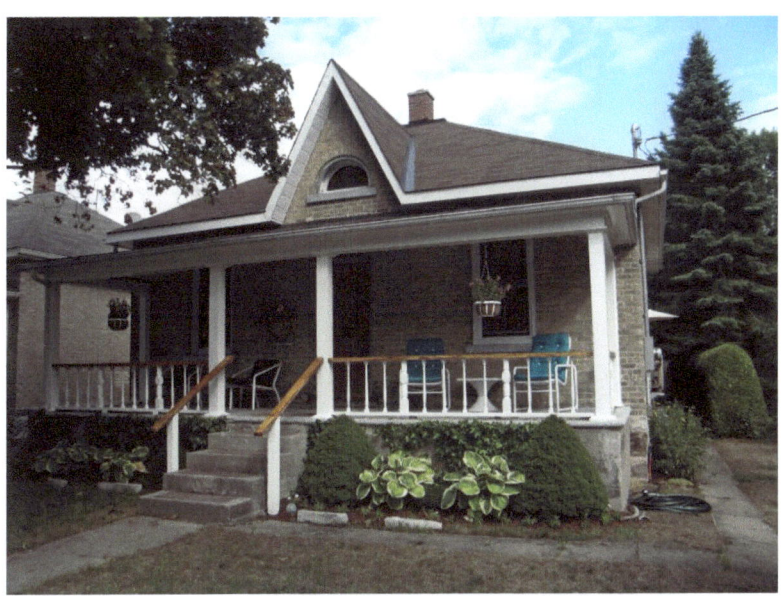

84 Huron South – A. F. Bowman, Manufacturer – c. 1912
One-and-a-half storey Gothic Revival cottage

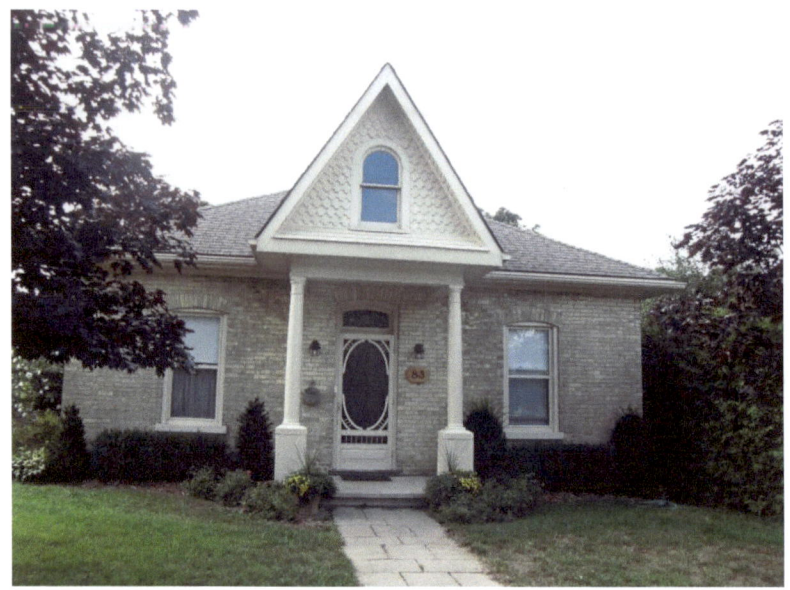
83 Huron South - One-and-a-half storey Gothic Revival cottage – yellow brick

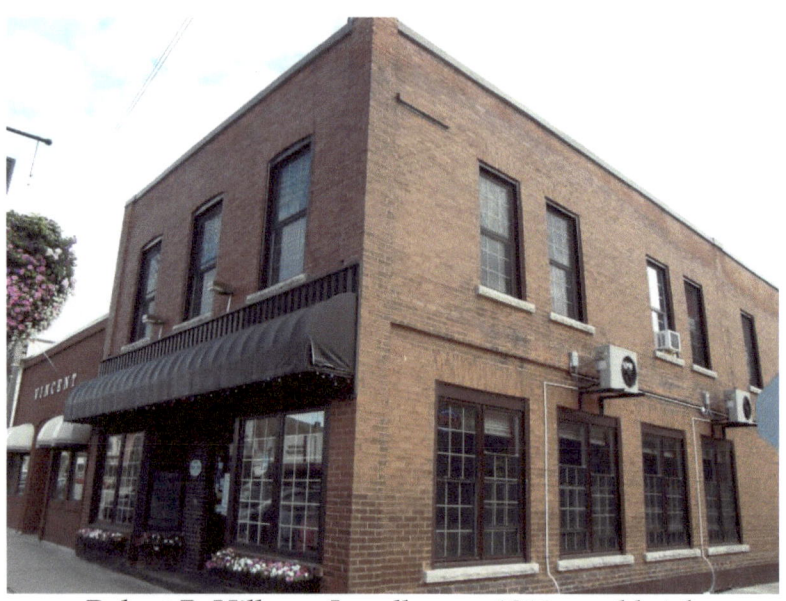
Robert B. Hillmer, Jeweller – c. 1911 – red brick

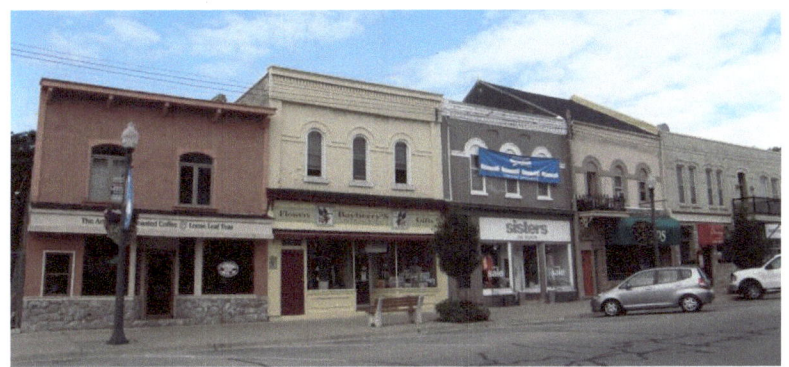

High Street

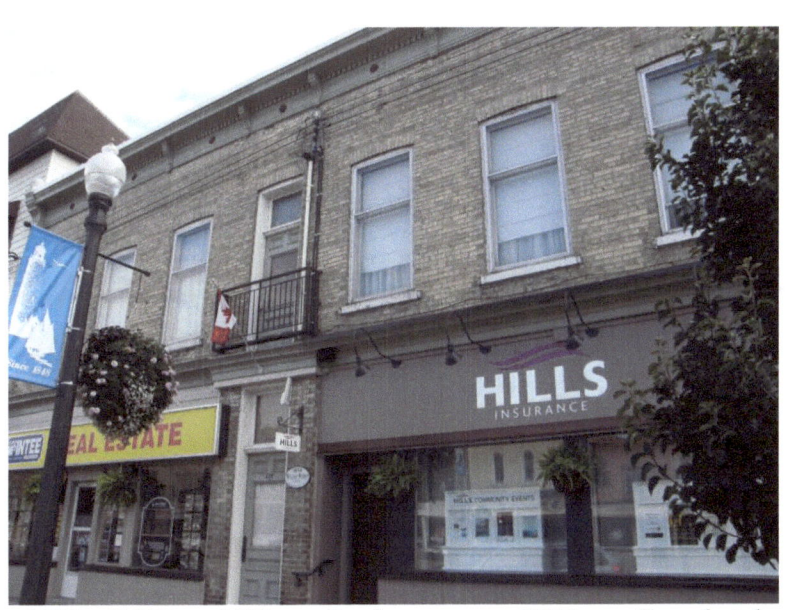

#179 – William Wilson, Innkeeper – c. 1854 – yellow brick

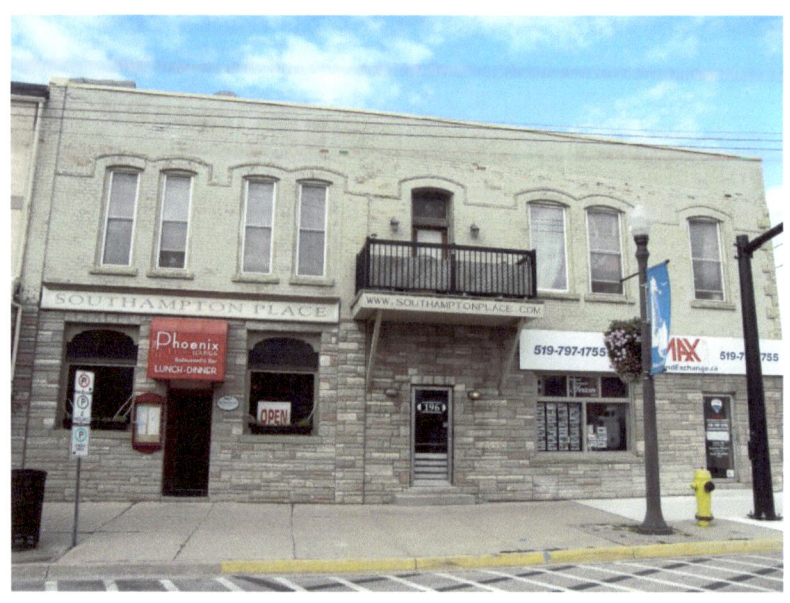

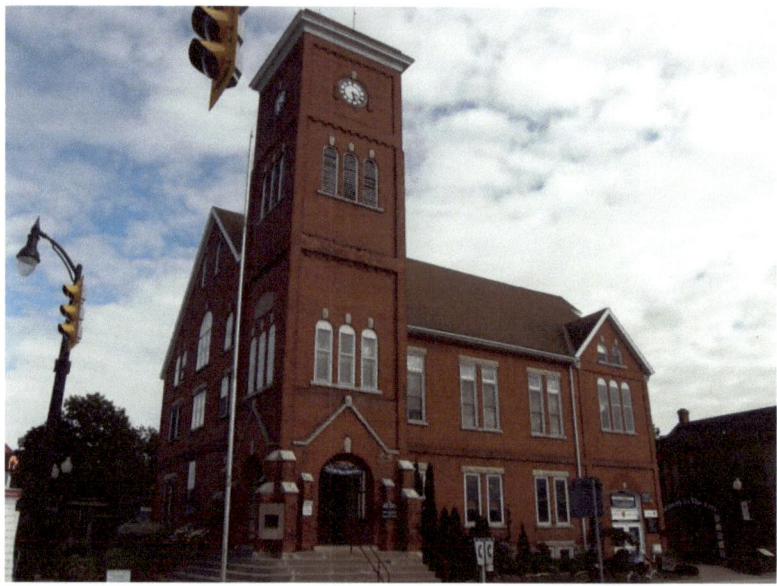

201 High Street - Town Hall erected A.D. 1910 – The clock in this tower was dedicated to the men from Southampton and the Saugeen Indian Reserve who gave their lives in the First Great War (1914-1918)

Yellow brick

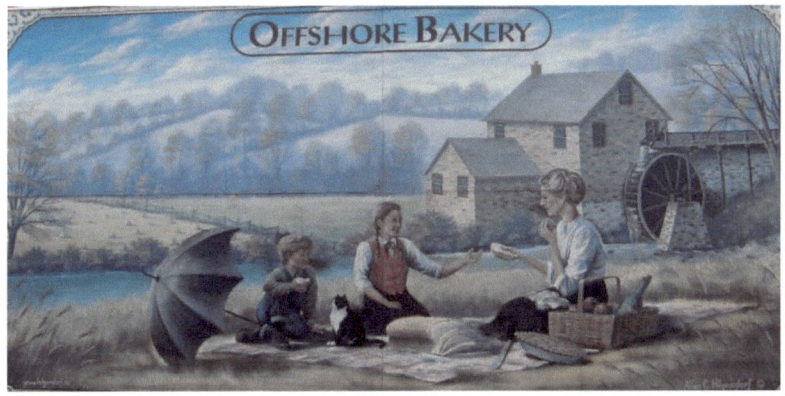

Mural

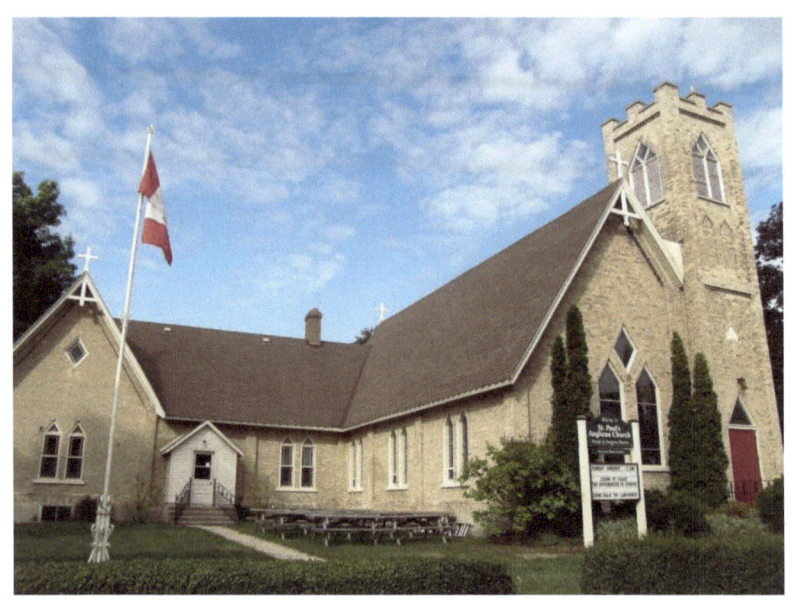

248 High Street - St. Paul's Anglican Church – A.D. 1887

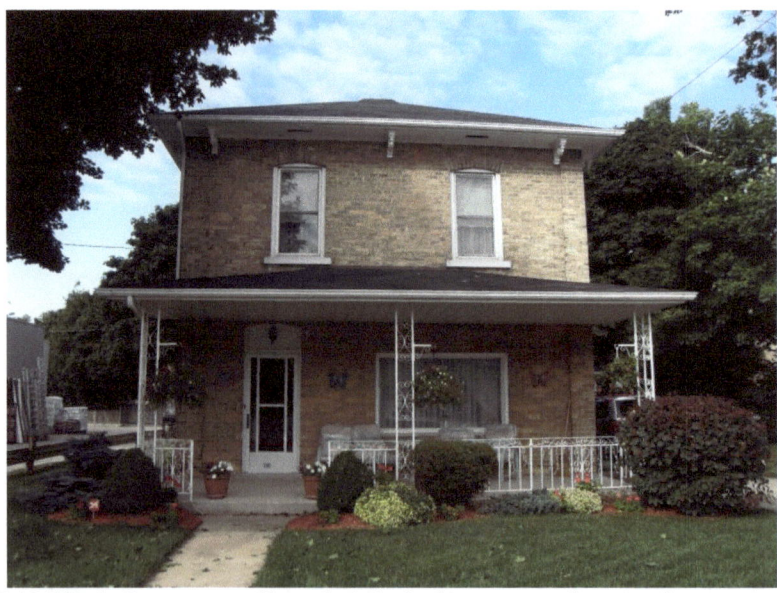

240 High Street – yellow brick, Italianate style, single cornice brackets

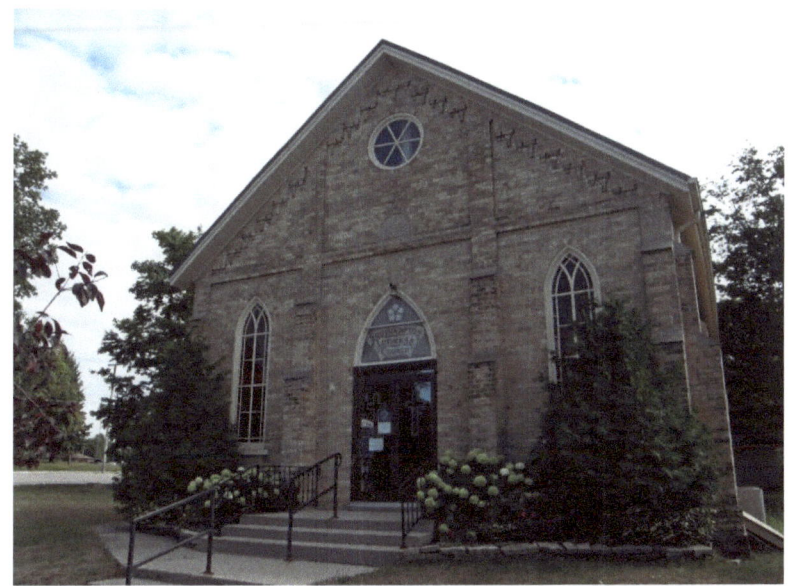

247 High Street - Southampton Lutheran Church
(formerly Baptist Church - A.D. 1907) – yellow brick

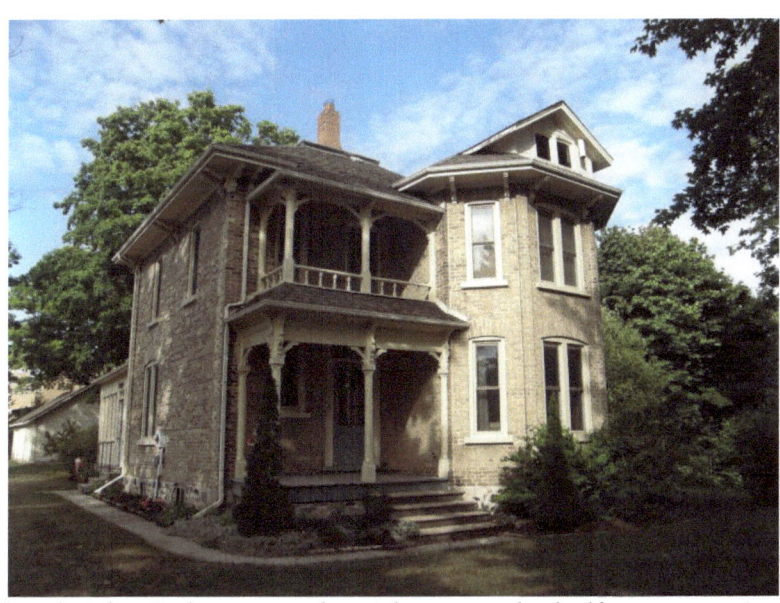

Yellow brick – Italianate style with two and a half storey projecting bay – cornice brackets

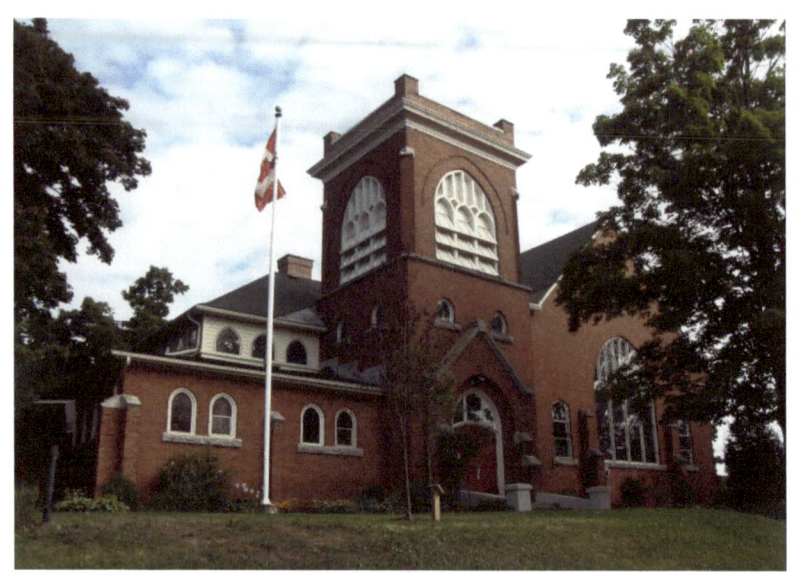

18 Victoria Street South
Southampton United Church

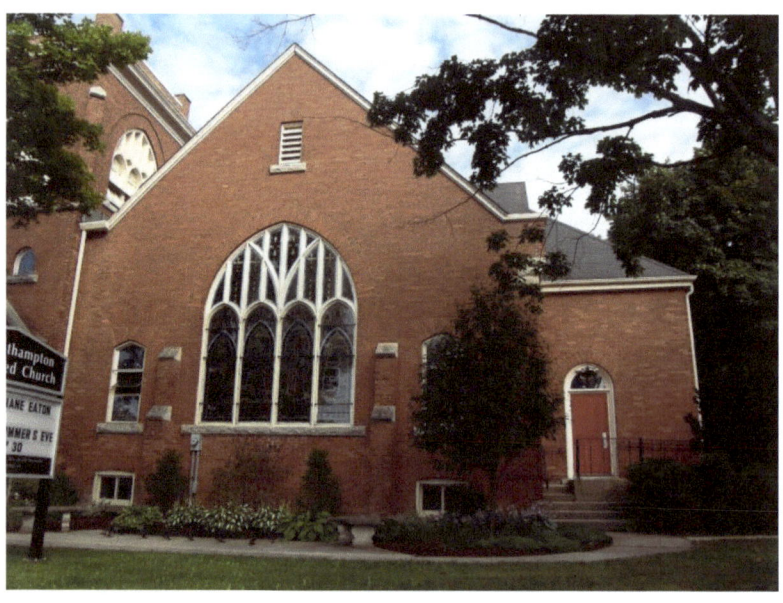

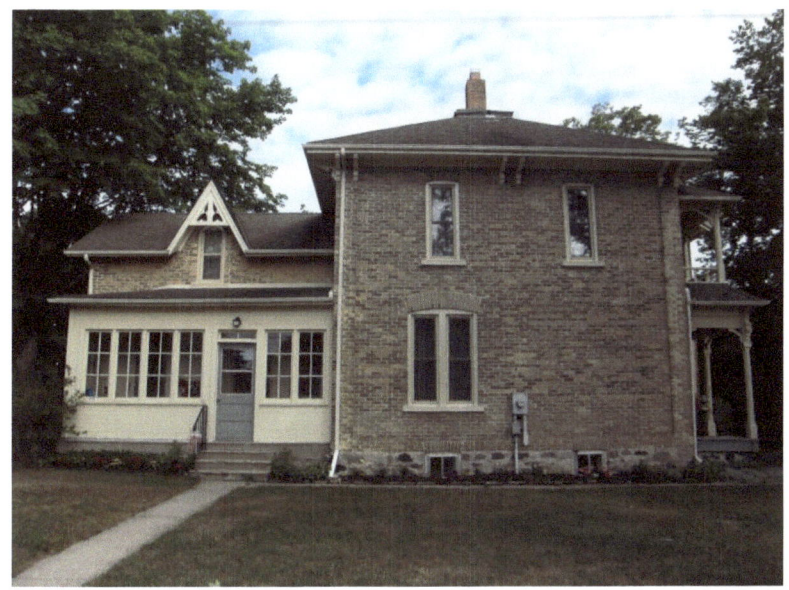

Gothic Revival/Italianate style – yellow brick, paired cornice brackets

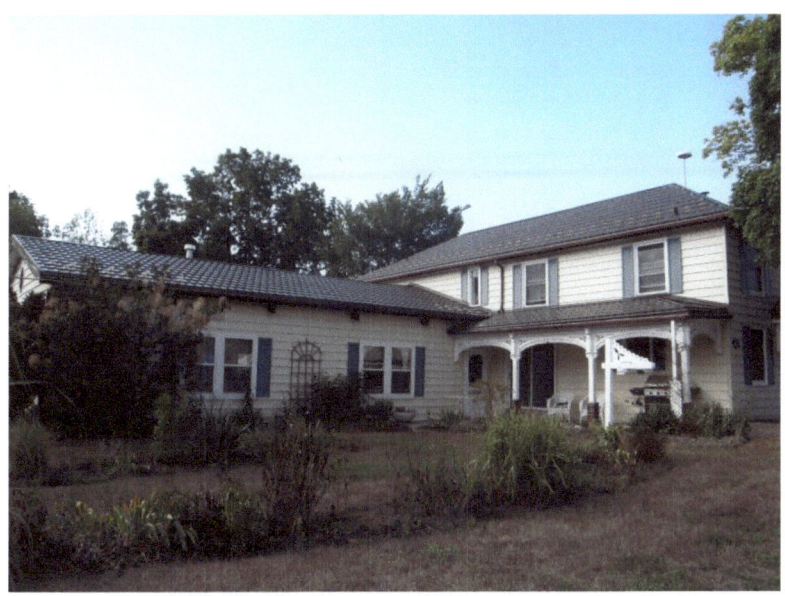

#48 - James Reed, Early Settler – c. 1878 – two-storey Italianate style with hipped roof, with one-storey Gothic wing

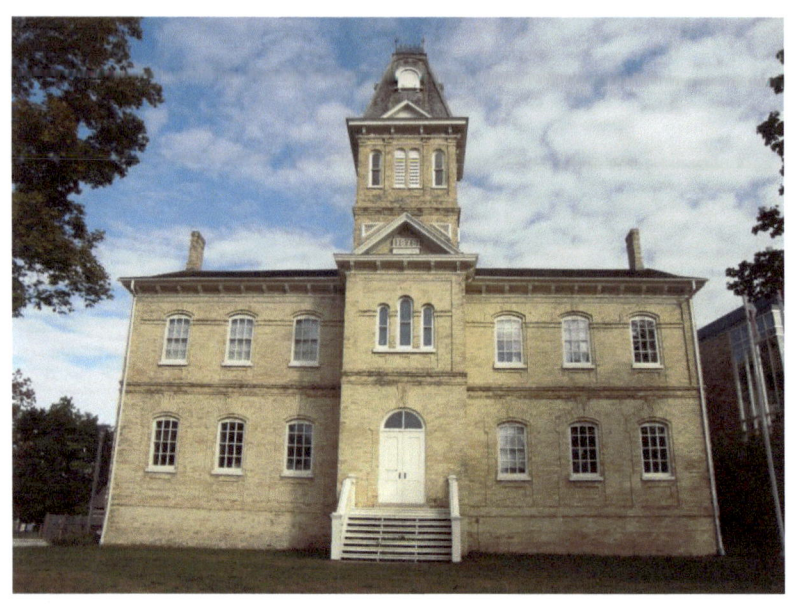

33 Victoria Street North, the old public school – now houses the Bruce County Museum and Cultural Centre - 1878 – yellow brick – Italianate style with Two-and-a-half storey tower-like bay with two-storey tower above, iron cresting on top

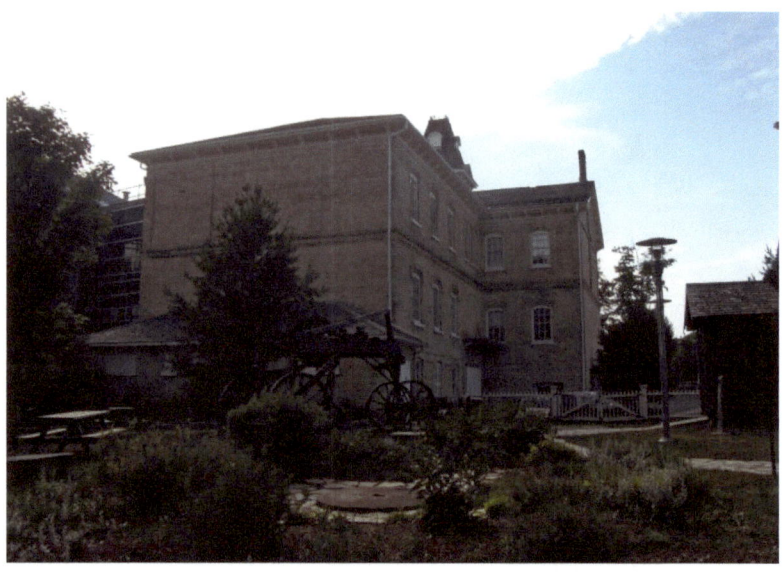

George McAulay, Captain – c. 1865

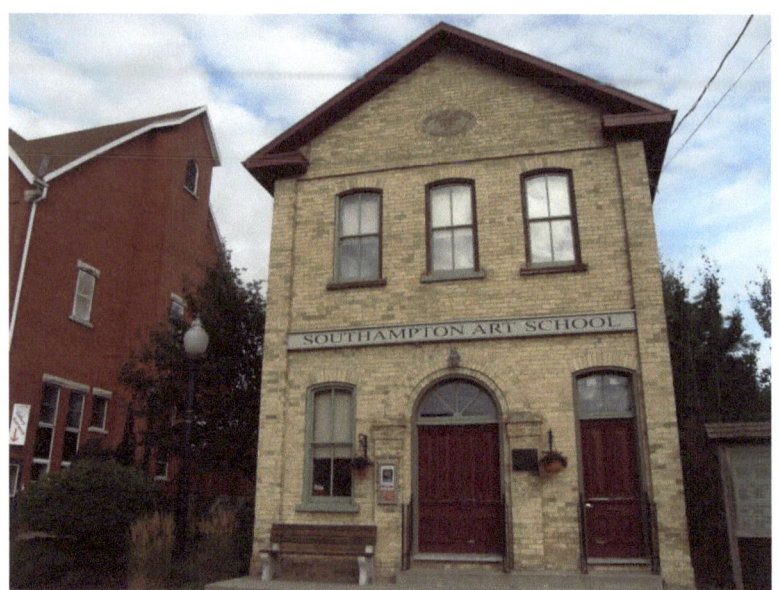

201 High Street – constructed by James Howe in 1887 as a private library and used as a Mechanics Institute until 1892; from 1896 to 1955 it housed a public library – yellow brick, Gothic Revival style In 1957 it became the Southampton Art School.

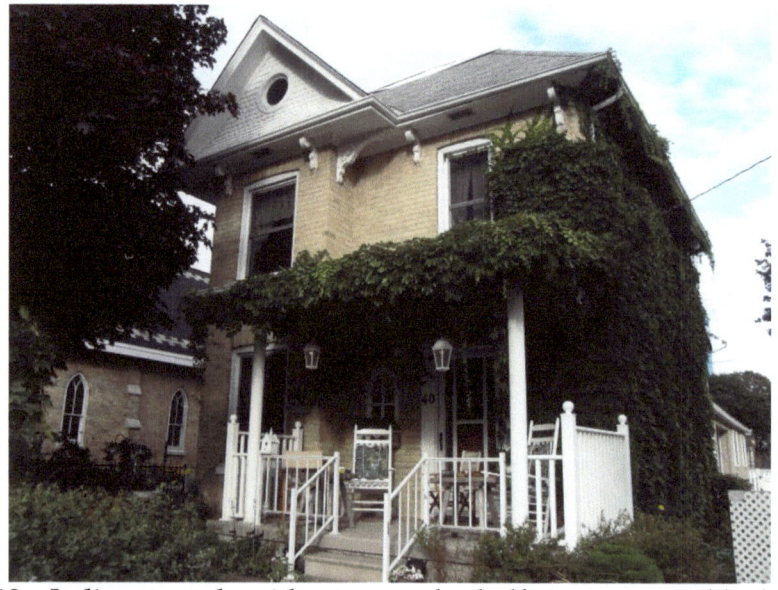

#40 – Italianate style with a two-and-a-half storey tower-like bay with projecting eaves and fretwork pieces resembling brackets

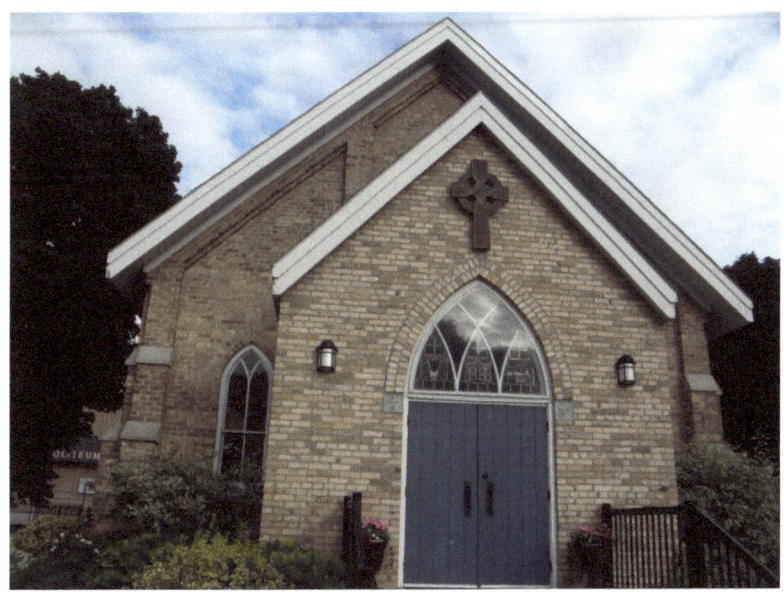

45 Portsmouth Road, St. Patrick's Roman Catholic Church

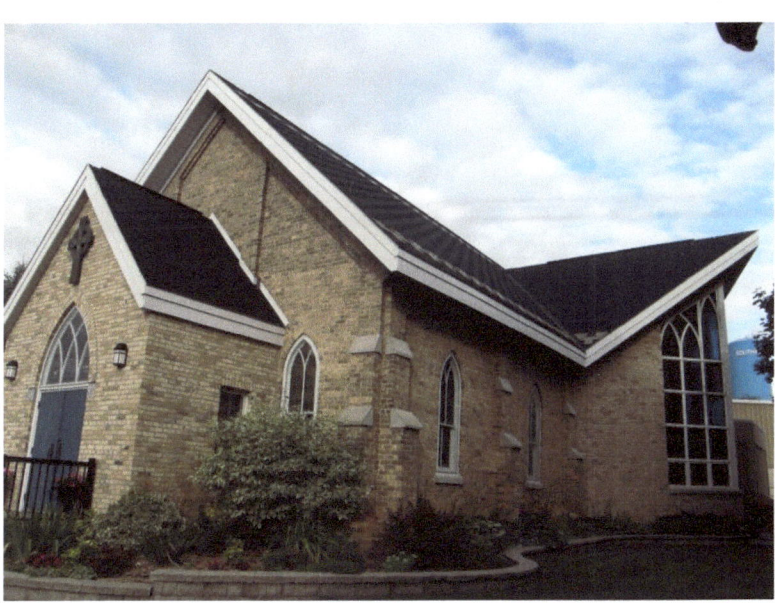

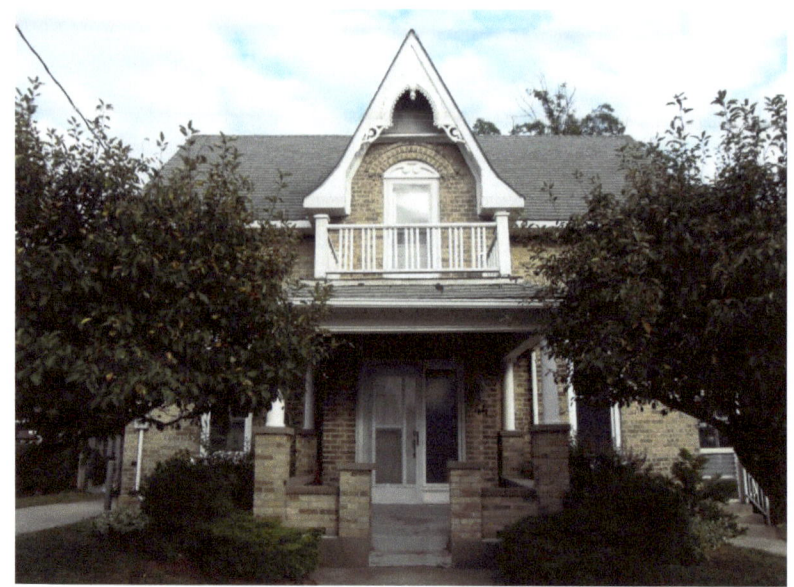

#44 – Gothic Revival – one-and-a-half storeys

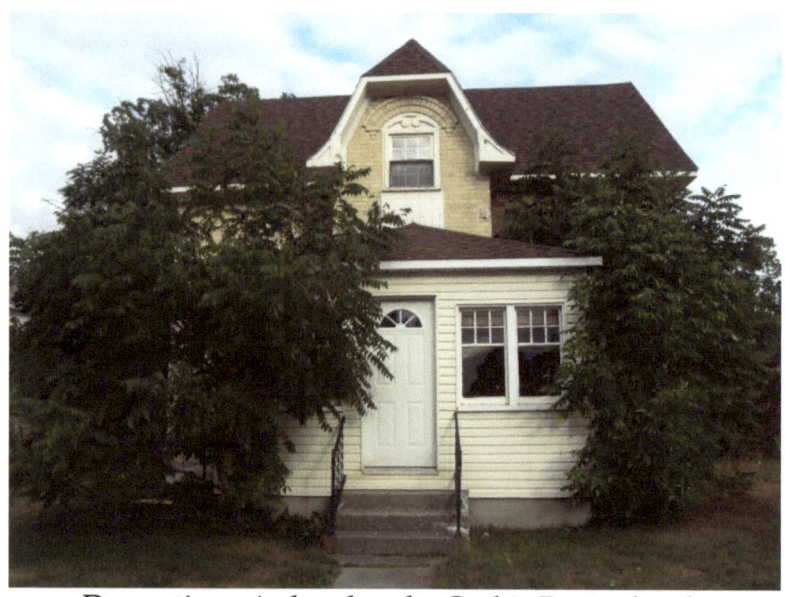

Decorative window hood – Gothic Revival style

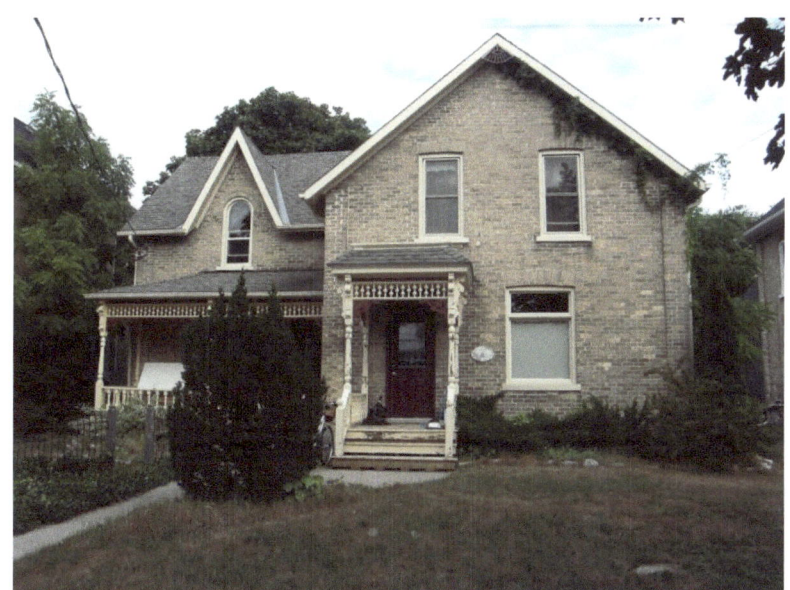

Levi Eby, Cabinet Maker – c. 1902 – yellow brick – Gothic Revival

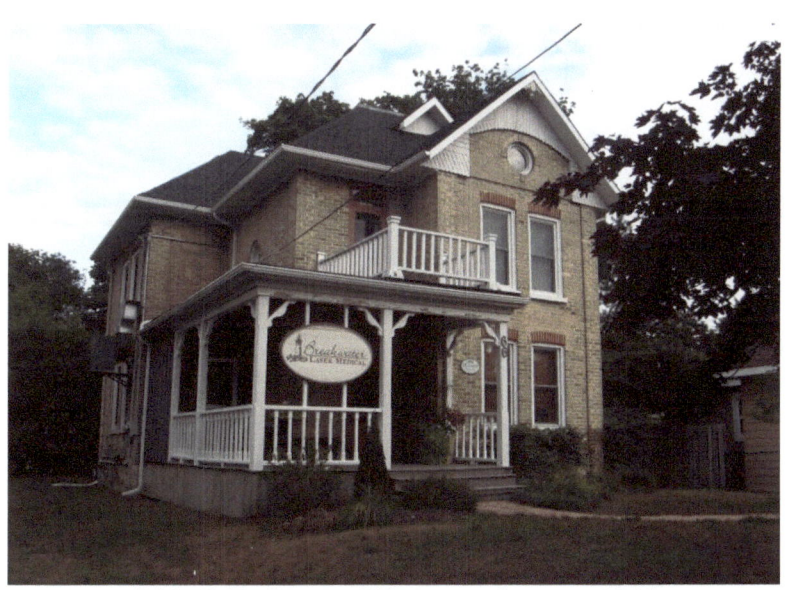

#66 - J. P. Coutts, Wagonmaker – c. 1896

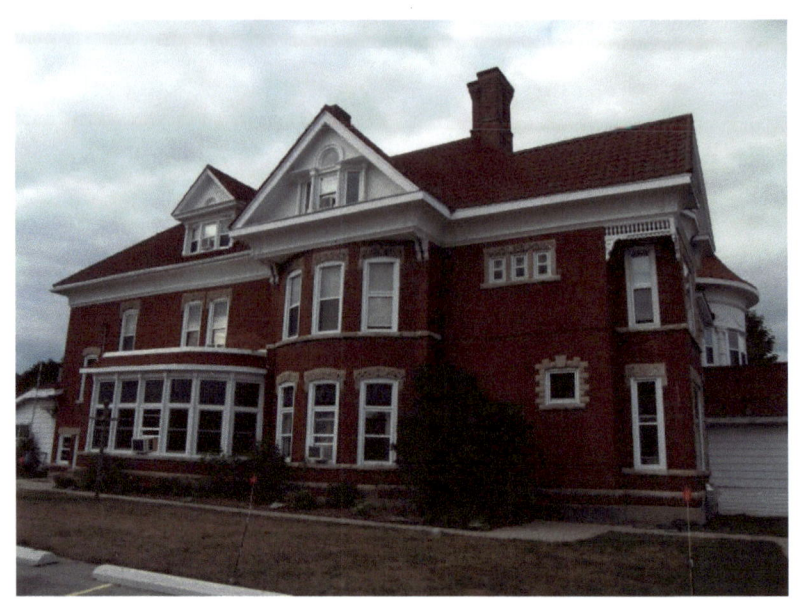

Queen Anne style

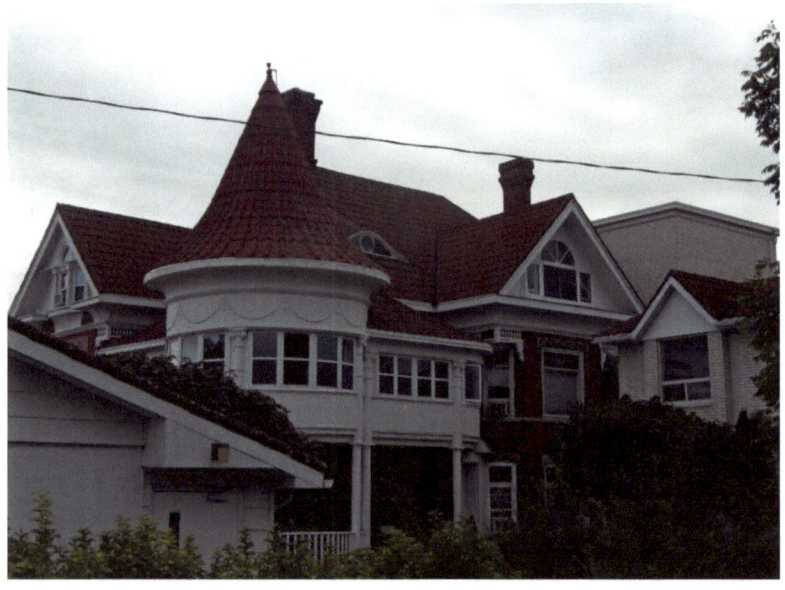

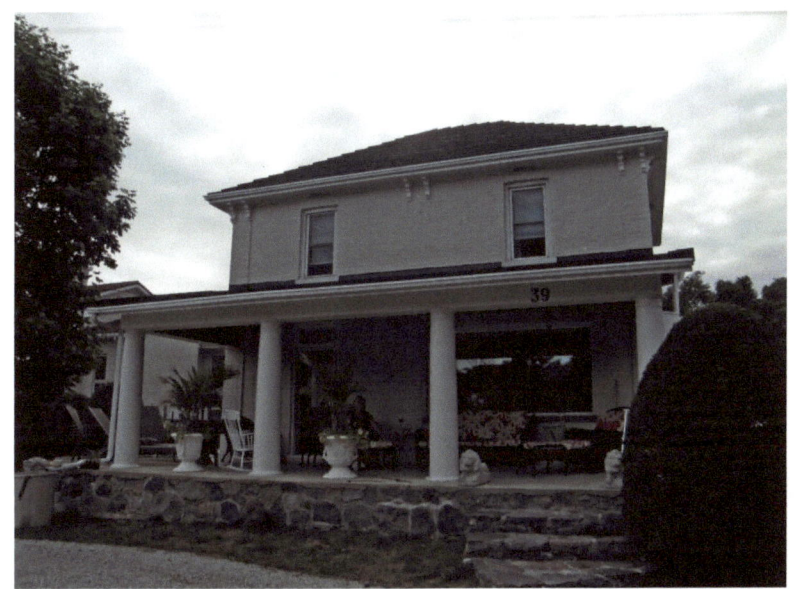

#39 – Thomas Morrison, Carpenter – c. 1878 – Italianate style

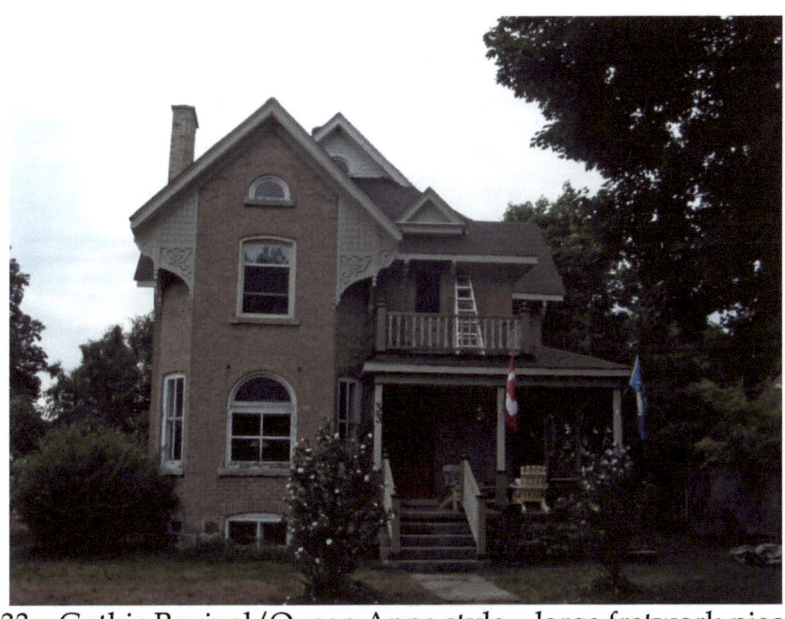

#33 – Gothic Revival/Queen Anne style – large fretwork pieces resembling brackets

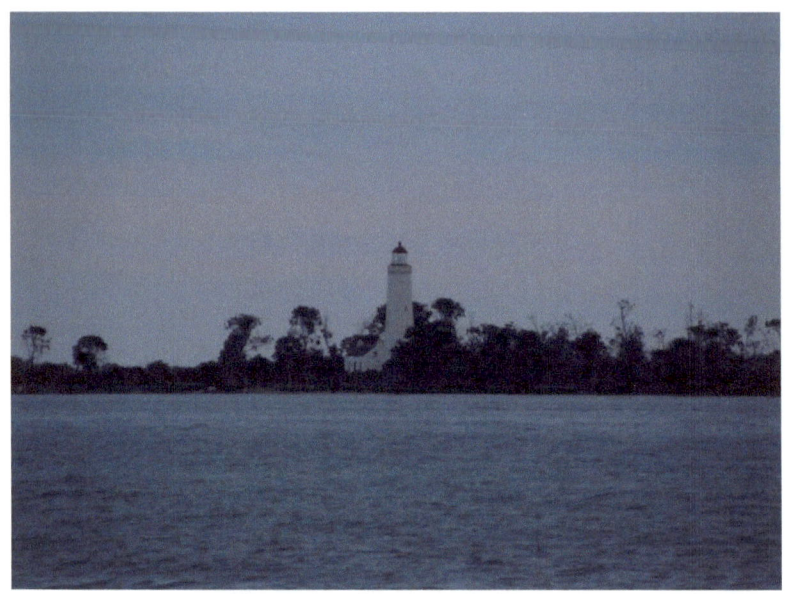
Chantry Island Lighthouse

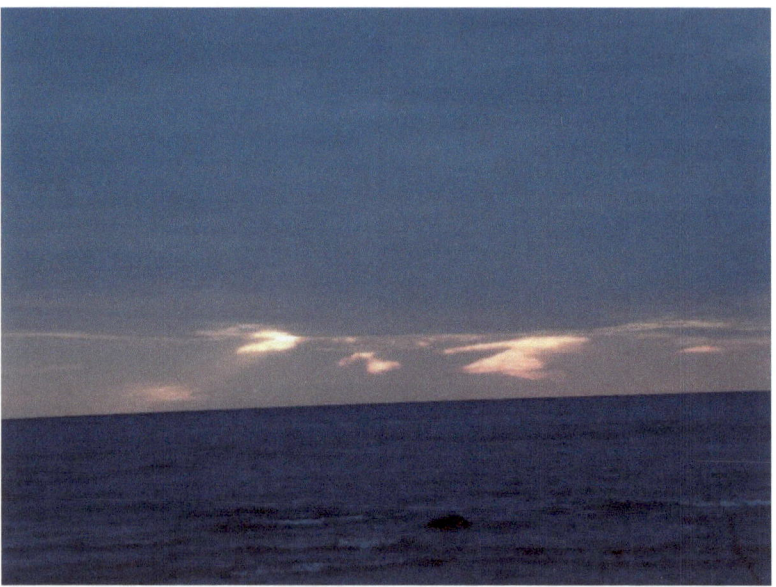
Sunset from the beach

Architectural Terms

Brackets: a decorative or weight-bearing structural element which forms a right angle with one side against a wall and the other under a projecting surface such as an eave or roof. Example: 25 Huron Street North	
Cobblestone architecture: Refers to the use of cobblestones embedded in mortar as a method for erecting walls on houses and commercial buildings. Example: Town Hall	
Cornice Return: decorative element on the end of a gable. Example: 118 High Street	
Fretwork: interlaced decorative design resembling a bracket	
Dormer: (French for "sleep") a gable end window that pierces through the plane of a sloping roof surface to create usable space in the top floor or attic of a building by adding headroom. Example: 135 High Street	
Gable: the triangular portion of a wall between the edges of a sloping roof. Example: 15 Huron Street North	
Hipped Roof: a roof where all sides slope downwards to the walls with no gables.	

Keystones and Voussoirs: a voussoir is a wedge-shaped element used in building an arch. A keystone is the central stone that locks all the stones into position, allowing the arch to bear weight. A keystone is often enlarged and embellished. Example:	
Lancet Window: a tall, narrow window with a pointed arch at its top. Example: 47 Albert Street	
Pediment: a triangular section above the horizontal structure (entablature), typically supported by columns. The inside of the triangle is called the tympanum.	
Quoin: masonry blocks at the corner of a wall, often a decorative feature, usually larger or of a different colour than the rest of the wall. Example: 118 High Street	
Turret: a small tower that projects from the wall of a building.	

Vergeboard and Finial: also called bargeboards – hang from the projecting end of a roof and are often elaborately carved and ornamented. **Finial:** ornament added to the top of a gable, pinnacle, canopy or spire – a Gothic element.	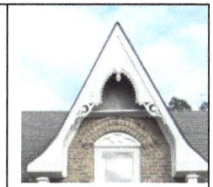
Window Hood: A **hood** is the piece found above window openings, usually of an ornate design, and covers the top third of the opening. Hoods are commonly placed above arched or curved openings on both windows and doors. Example:	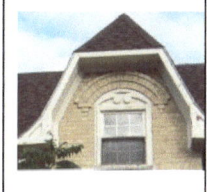

Southampton's Building Styles

Gothic Revival, 1830-1890 – These decorative buildings have sharply-pitched gables with highly detailed vergeboards, pointed-arch window openings, and dichromatic brickwork. It is a common style in Ontario. Example: Levi Eby house	
Italianate, 1850-1900 – It has wide-bracketed eaves, belvederes, wrap-around verandahs. Example: 240 High Street	
Queen Anne, 1885-1900 – This style has an irregular outline with a combination of an offset tower, broad gables, projecting two-storey bays, verandahs, multi-sloped roofs, and tall, decorative chimneys. Example: 107 High Street	
Regency Cottage, 1830-1860 – This style originated in England in 1815 and spread to Ontario later in the 19th century as British officers retired to Canada. It is a modest one-storey house with a low-pitched hip roof and has a symmetrical front façade. Example: 18 Huron Street North	

www.ingramcontent.com/pod-product-compliance
Lightning Source LLC
Chambersburg PA
CBHW041150180526
45159CB00002BB/770